THE QUOKKA'S GUIDE TO

HAPPINESS

ALEX CEARNS

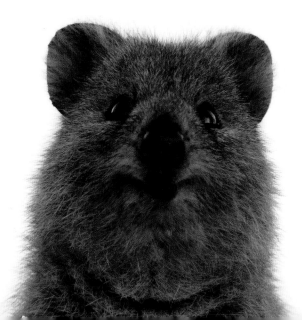

ABC
BOOKS

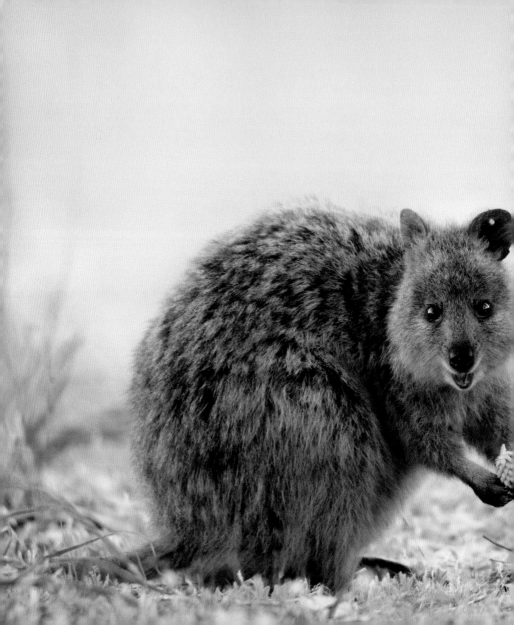

To Macy

introduction

Quokkas are adorably cute, remarkably unique and very photogenic. With their cheeky grins and lovable personalities, it's no wonder they were given the title 'the happiest animal on the earth' by *The Huffington Post* in 2013.

When the opportunity presented itself to photograph quokkas for this book, I jumped at the chance. They are adored by all who meet them, and I had fond memories of previous visits to their island home, Rottnest Island, and became enthralled by their antics.

What an absolute joy it was to photograph quokkas while they (mostly) ate, played and interacted with each other. Some were very friendly and would run towards me at full speed, as if we were long-lost friends. Others were more cautious in their approach, but as soon as I sat still, their curious natures would get the better of them and they would slowly come closer and then act like I wasn't even there – which generally meant they got on with eating.

I made several visits to Rottnest Island to capture the images contained in these pages, and it was a great privilege to stop and sit quietly with hundreds of quokkas for hours on end and to get to know them better than I would have if I'd just taken a brief selfie with a mobile phone.

I hope you enjoy this book as much as I enjoyed taking the photographs for it. (For information on how to photograph a quokka safely and respectfully, see page 130.)

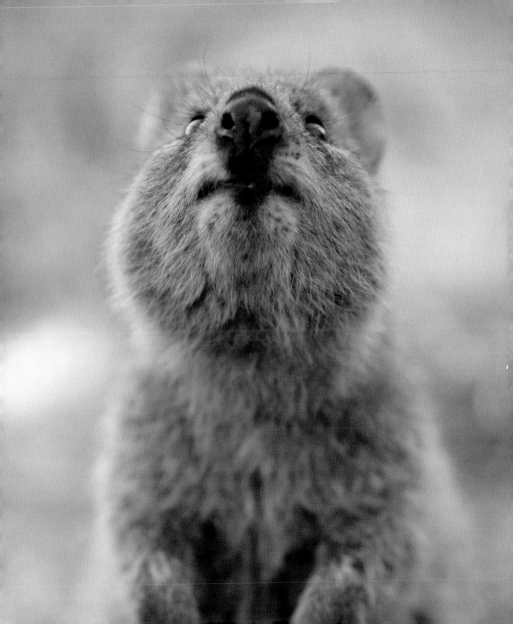

meet the quokkas

Quokkas are one of the smallest species of wallaby and belong to the family of herbivorous pouched marsupials called the macropod. (The term 'macropod' describes the family of large-footed, kangaroo-like marsupials native to Australia and the surrounding islands. This family includes kangaroos, quokkas, bettongs, wallabies, tree kangaroos, pademelons and wallaroos.)

The unusual-sounding name 'quokka' comes from the Australian Aboriginal Nyungar language word 'gwaga'. The quokka's scientific name is *Setonix brachyurus*.

Quokkas have small stocky bodies, rounded fluffy ears, a coarse thick coat and a long skinny tail. Quokkas grow to the size of a domestic cat and can live for up to ten years. Like kangaroos, quokkas have strong back legs, which they use to bound through thick vegetation and tunnels they create in the undergrowth.

Loved most for their happy, expressive faces, the famous quokka smile is formed by the natural curve of their little black snout. Just like dogs, quokkas open their mouths to pant when they're hot. It looks like they're breaking out into an irresistible smile, but this is actually an evolutionary feature that helps them cool off.

This friendly facial expression is easier to believe because quokkas are naturally gentle and inquisitive. They have little fear of humans and will hop right up to a delighted visitor on Rottnest Island to seemingly demand attention – but beware! Despite their friendly demeanour, quokkas do not like to be handled.

They are still wild animals with very sharp claws, and will bite and scratch if they feel threatened. It is common for children on Rottnest to suffer minor injuries from trying to pick them up.

The Australian government has strict rules about not touching quokkas, so getting too close and personal could result not just in scratches but also a fine.

If you want to snap a quokka selfie, and have the good fortune of being close enough to do so, stand still and be patient – a quokka is more than likely to come up to you. (For more about photographing quokkas, see page 130.)

where do quokkas live?

Quokkas can only be found in small areas of south-west Western Australia. Most live on Rottnest Island, a magnificent nature reserve and popular tourist destination located 33 kilometres (approximately 21 miles) off the coast of Perth, Western Australia.

These tiny marsupials roam freely all over Rottnest Island, where their survival is largely attributed to the lack of predators. More than 12,000 quokkas live in peaceful, stable populations on the island.

babies

Quokkas breed in late summer. After a month-long gestation, a female will give birth to a single joey that remains in the pouch for around six months. After the joey leaves the pouch, he or she will continue to nurse for up to another three months before becoming fully independent.

vital statistics

Quokkas can weigh as much as 4.5 kilograms (10 pounds) and their
bodies can reach 40–54 centimetres (16–21 inches) plus a tail length
of 25–30 centimetres (10–12 inches).

The fastest recorded speed of a quokka is 32 kilometres per hour
(20 miles per hour).

An interesting fact: research into treating a muscle-wasting disease found
in some quokkas has become the foundation of new methods to treat
humans suffering muscular dystrophy.

diet

These adorable mammals are herbivores and satisfy their dietary requirements
by browsing on nearby grasses and other plant material such as shrubs, bark
and succulents. They can also climb onto the lower limbs of trees to eat leaves,
and fruits and berries when available. They often swallow their food without
chewing, but then regurgitate the undigested material to eat later in the
form of a cud. The cud effectively retains most of the moisture and nutrients
available from the dry vegetation in the quokkas' habitat.

Quokkas can survive long periods of time without drinking from a direct water
source. When availability of food is low, they can go for months by living off
the fat stored in their tails.

Other than food from their natural environment, quokkas have no need
for 'human food' — bread and salty food such as chips and meat can lead to
malnourishment and even death. Consequently, it is illegal for any member
of the public to feed them. Hefty fines apply for anyone who deliberately
feeds them.

social environment

Quokkas are highly social and live in large colonies and overlapping groups. On Rottnest Island, some colonies reach up to 150 members around a good water source. Territories are generally peaceful, but occasionally fights break out on hot days between dominant males that vie for the shadiest spot.

As nocturnal animals, quokkas are most active at night when they browse for food and interact with family and friends. On Rottnest Island, they have adapted their activity to be around tourists during the day, but most rest under shady trees and in dense shrubbery in the heat.

protected species

Quokkas have not been domesticated in any way. It is illegal to own a quokka as a pet or handle them without permission from the Rottnest Island Authority.

Quokkas are currently ranked as 'vulnerable' under both the International Union for Conservation of Nature's Red List and *Australia's Environment Protection and Biodiversity Conservation Act 1999*. Without this protection they risk becoming extinct in the wild, particularly on the mainland of south-west Western Australia, where they and or their habitat are vulnerable to attack by feral animals.

Increasing popularity and internet stardom has actually improved the quokka's chances of long-term survival. Population numbers were declining until rising public interest garnered greater attention and more funding for protection and research.

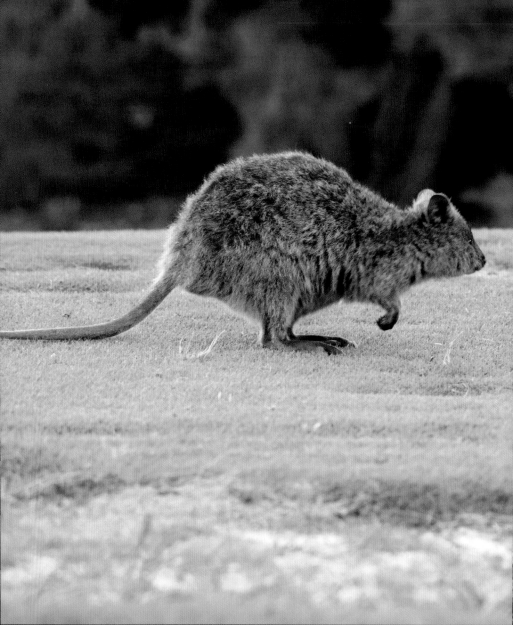

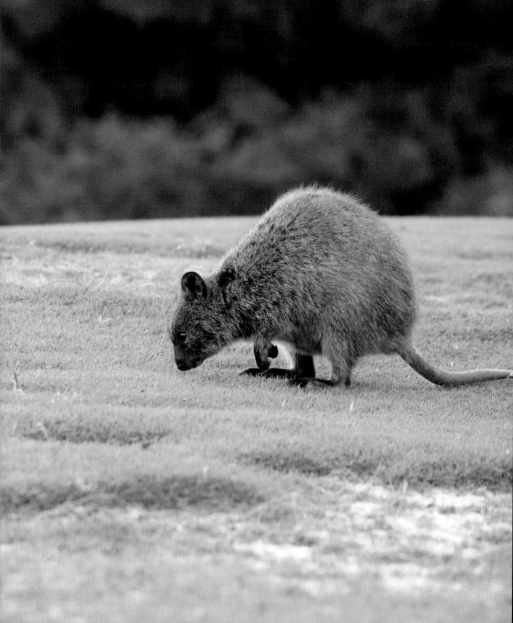

'tis substantial

happiness to eat'

———————

ALEXANDER POPE

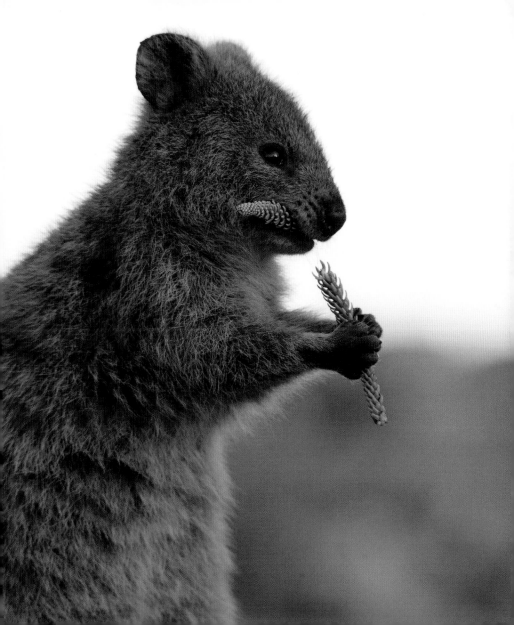

'Even the darkest night
will end, and the
sun will rise'

———

VICTOR HUGO

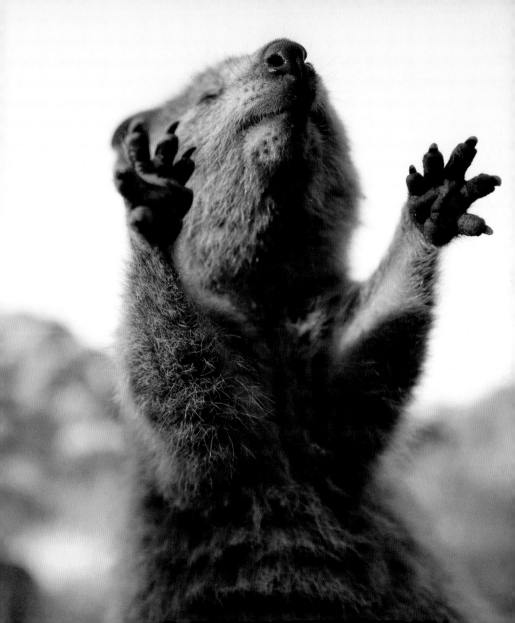

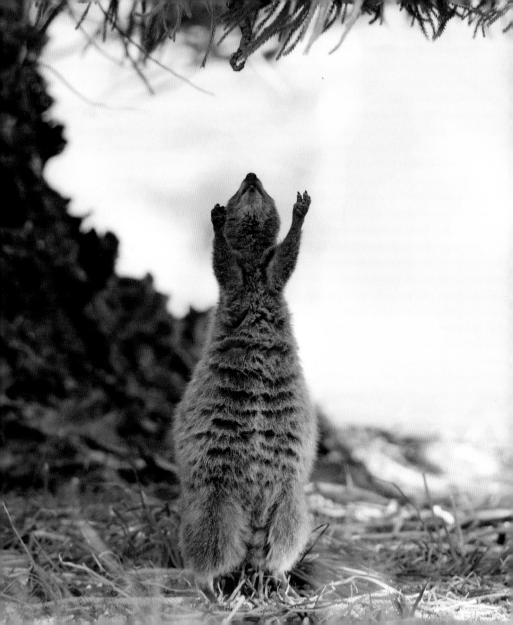

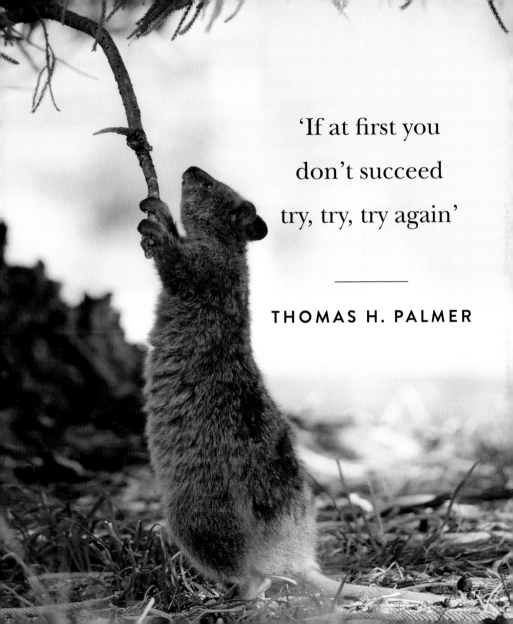

'If at first you
don't succeed
try, try, try again'

———

THOMAS H. PALMER

'Happiness quite
unshared can scarcely
be called happiness –
it has no taste'

———

CHARLOTTE BRONTË

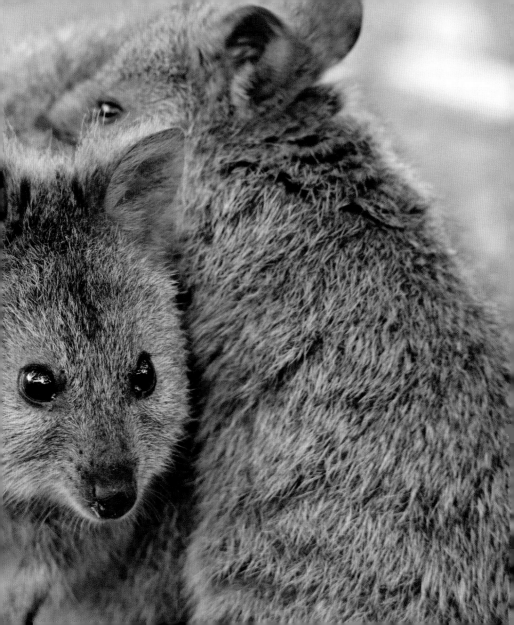

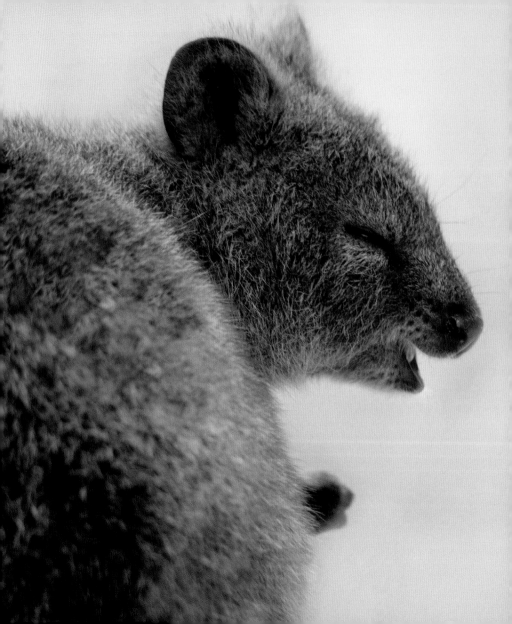

'One sees clearly only with the heart. Anything essential is invisible to the eyes'

————

ANTOINE DE SAINT-EXUPÉRY

'Be thou the rainbow in the

storms of life!

The evening beam that smiles

the clouds away,

And tints tomorrow with

prophetic ray!'

———

LORD BYRON

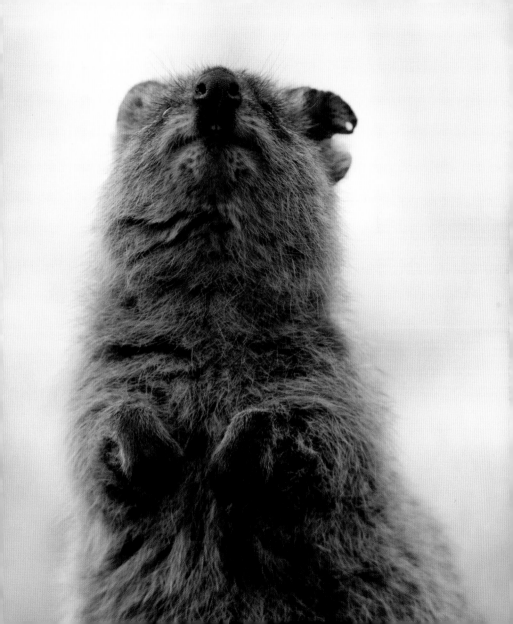

'Happiness always looks small while you hold it in your hands, but let it go, and you learn at once how big and precious it is'

———

MAXIM GORKY

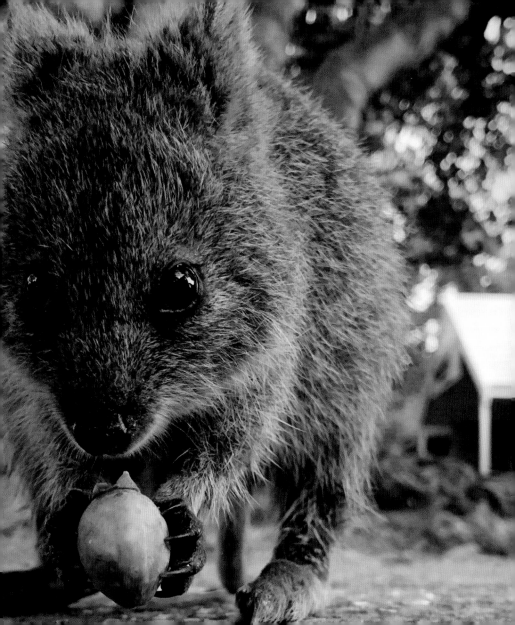

'He has achieved success
who has lived well, laughed
often and loved much'

—————

BESSIE ANDERSON STANLEY

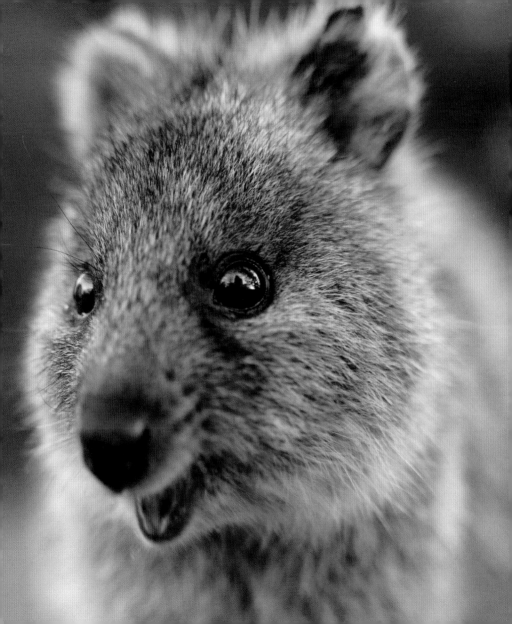

'The supreme happiness of life consists in the conviction that one is loved; loved for one's own sake – let us say rather, loved in spite of one's self'

VICTOR HUGO

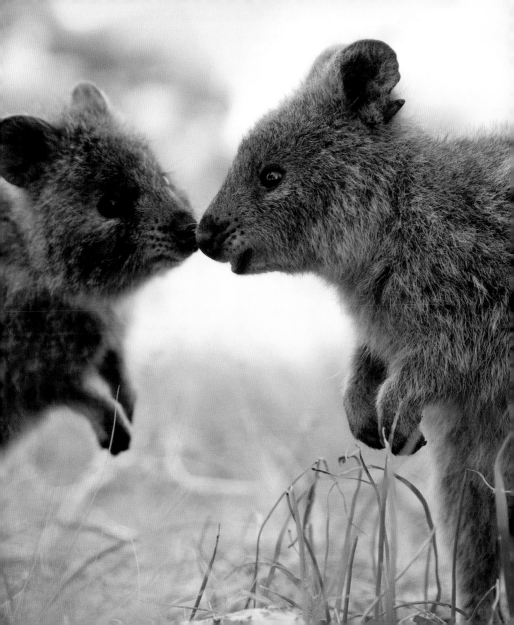

'Fortune helps
those who dare'

———

VIRGIL

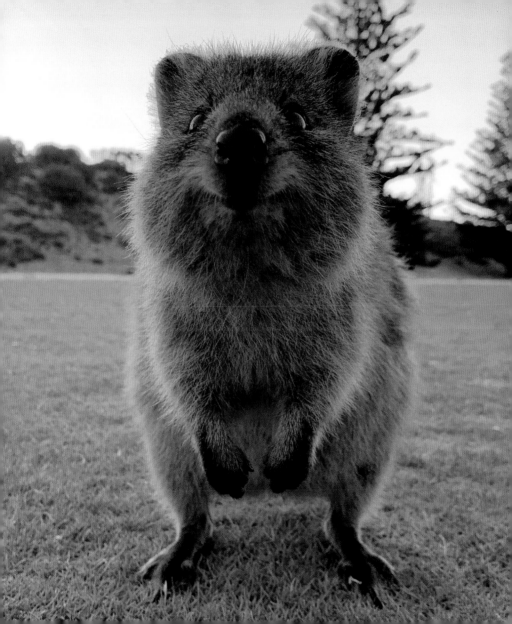

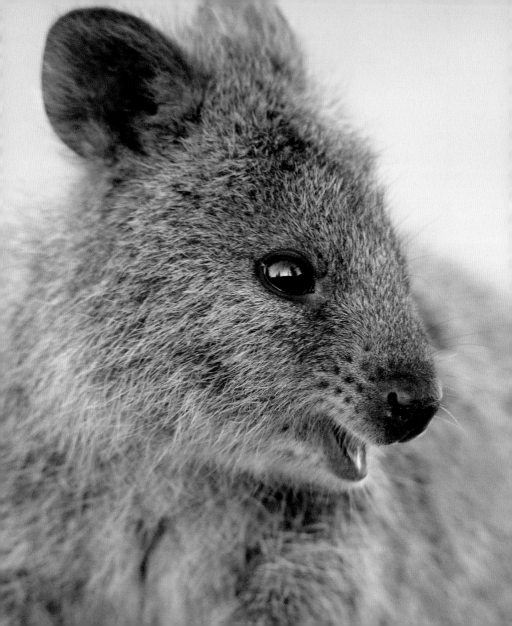

'A thing of beauty

is a joy forever'

———

JOHN KEATS

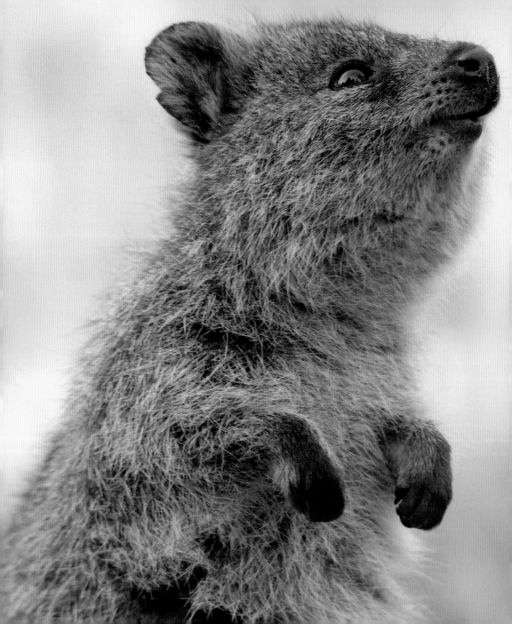

'Our greatest glory is
not in never falling,
but in rising every
time we fall'

OLIVER GOLDSMITH

'Laughter is the sun
that drives winter from
the human face'

———————

VICTOR HUGO

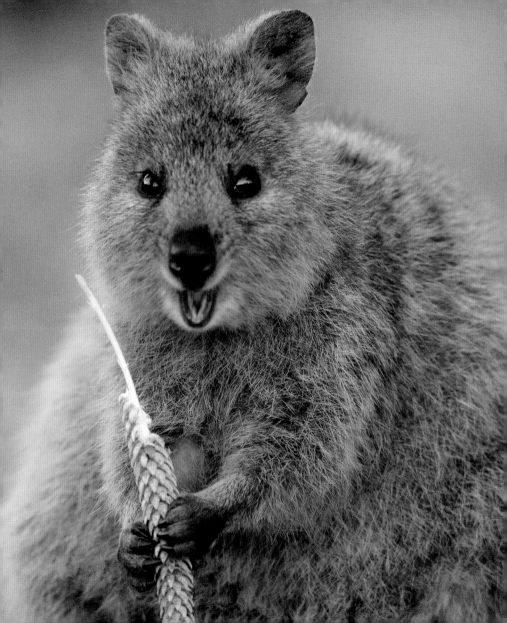

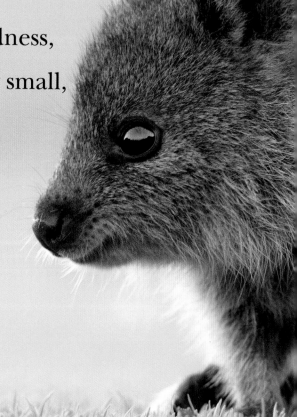

'No act of kindness,
no matter how small,
is ever wasted'

———————

AESOP

'When you are content to
be simply yourself and don't
compare or compete, everybody
will respect you'

———

LAOZI

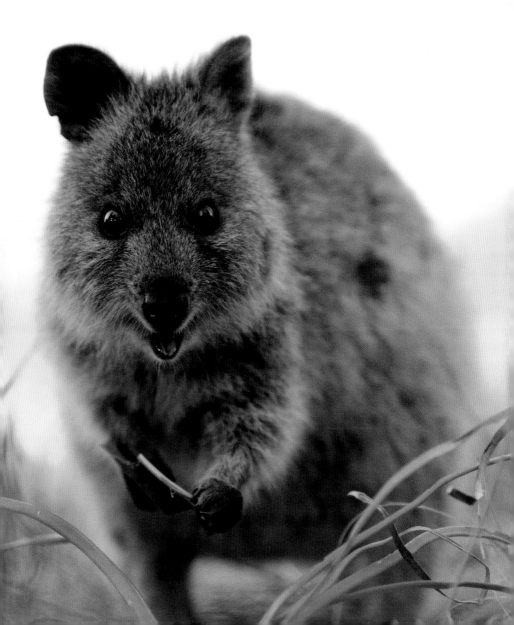

'Action may not always be happiness … but there is no happiness without action'

BENJAMIN DISRAELI

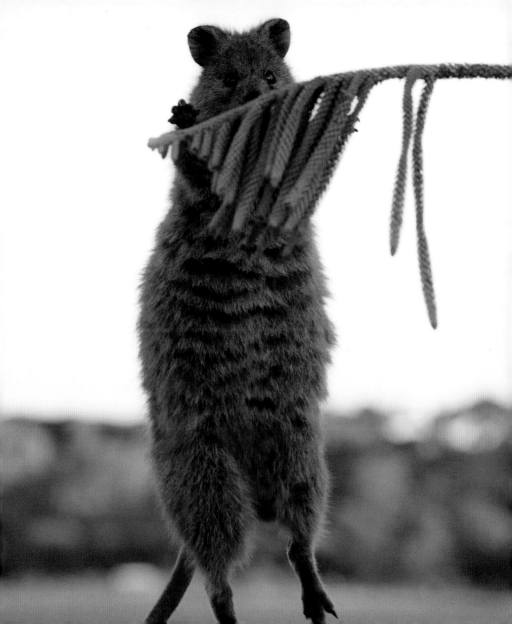

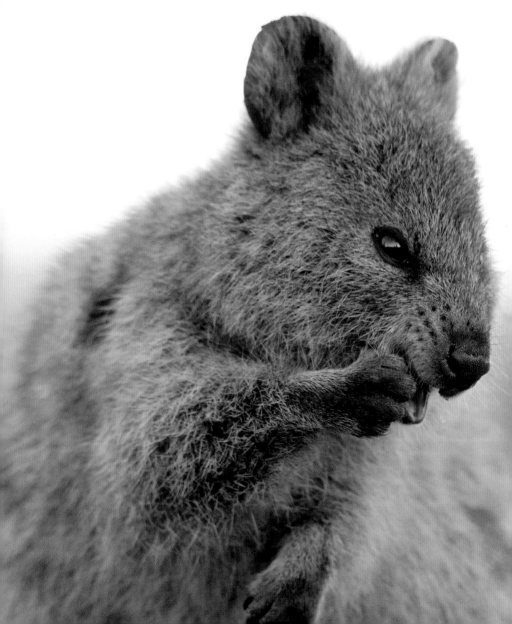

'Do not dwell in the past,
do not dream of the future,
concentrate the mind on
the present moment'

———————

BUDDHA

'I know not all that may be
coming, but be it what it will,
I'll go to it laughing'

———————

HERMAN MELVILLE

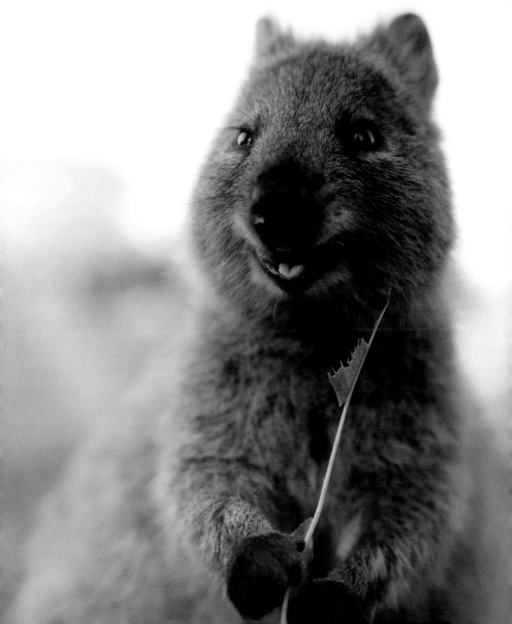

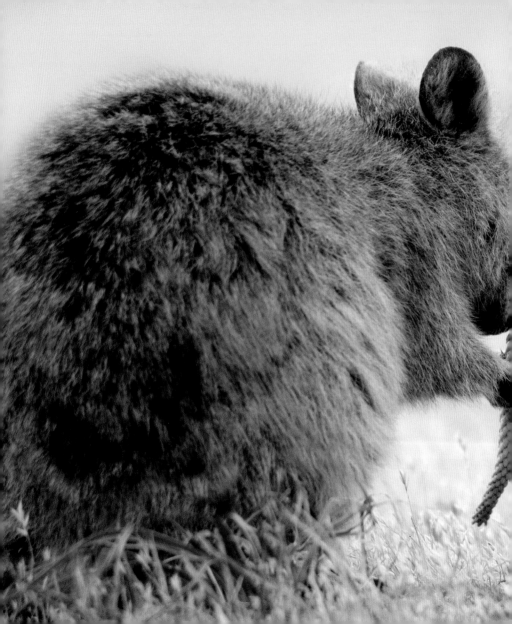

'To fill the hour –
that is happiness'

————

RALPH WALDO EMERSON

'There is no duty we so much underrate as the duty of being happy. By being happy we sow anonymous benefits upon the world'

ROBERT LOUIS STEVENSON

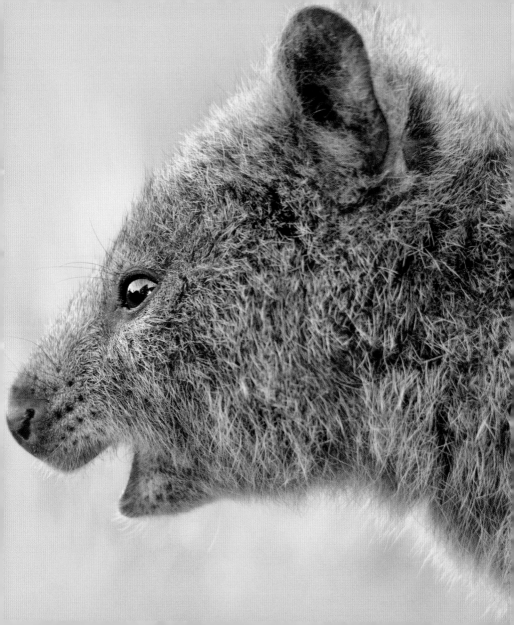

'If it's sanity you're after,
there's no recipe like laughter.
Laugh it off'

———

HENRY RUTHERFORD ELLIOT

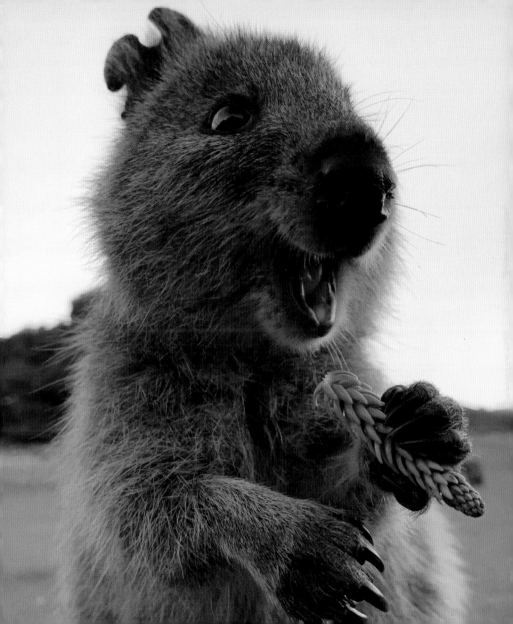

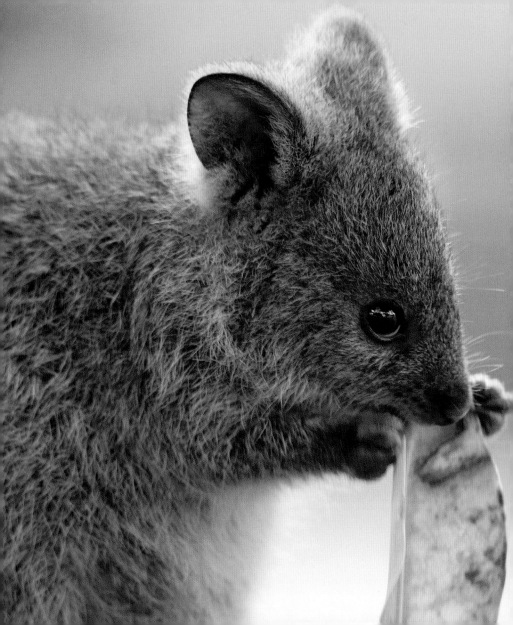

'Happiness is something more than a mere permanent state or condition of the mind … it consists in some form of activity'

———

ARISTOTLE

'The foolish man
seeks happiness in the
distance, the wise grows
it under his feet,'

JAMES OPPENHEIM

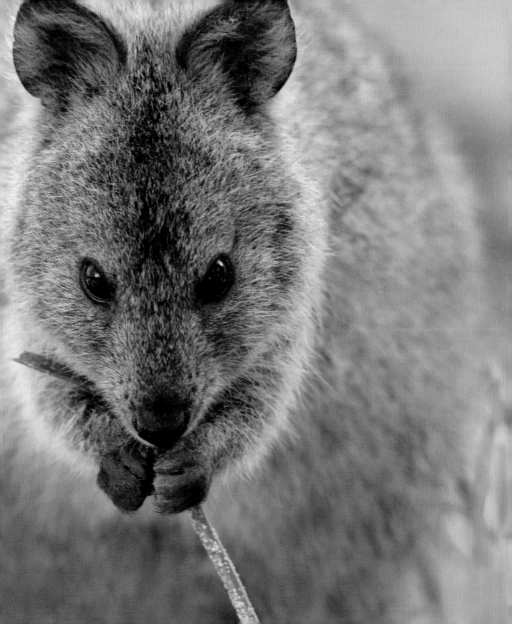

'Experience tells us that love does not exist in gazing at each other but in looking together in the same direction'

ANTOINE DE SAINT-EXUPÉRY

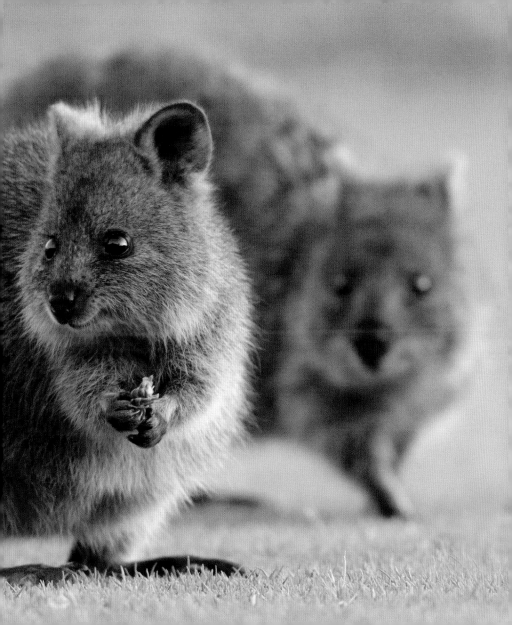

'Let us be grateful to
the people who make
us happy; they are
the charming gardeners
who make our
souls blossom'

MARCEL PROUST

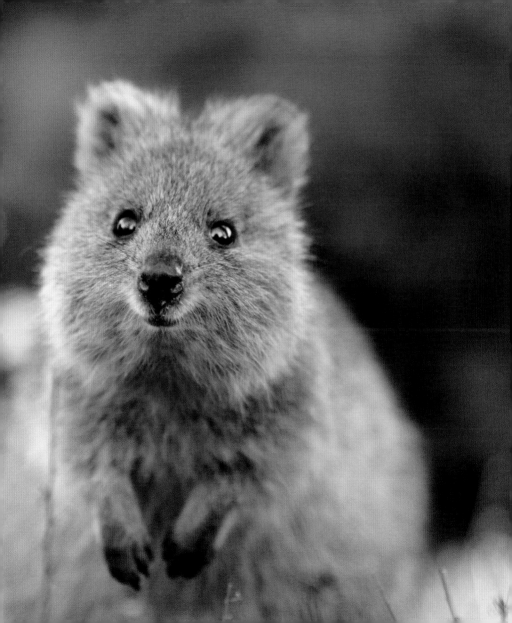

'Joy in looking and
comprehending is nature's
most beautiful gift'

———

ALBERT EINSTEIN

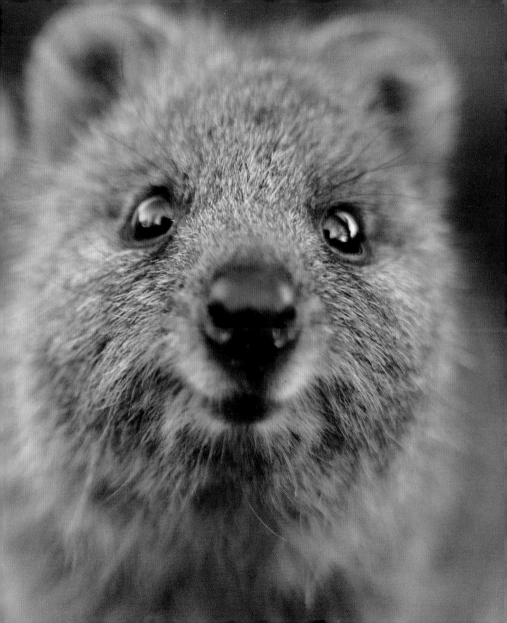

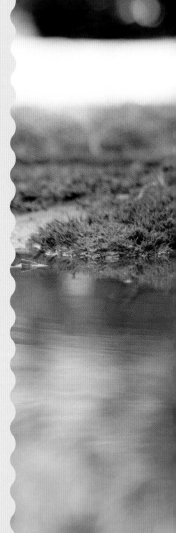

'One doesn't discover
new lands without
consenting to lose sight,
for a very long time,
of the shore'

———

ANDRÉ GIDE

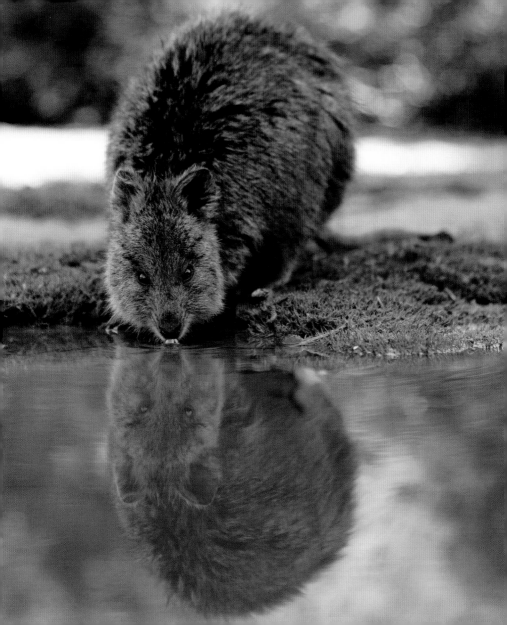

There is only one

happiness in life,

to love and be loved

———————

GEORGE SAND

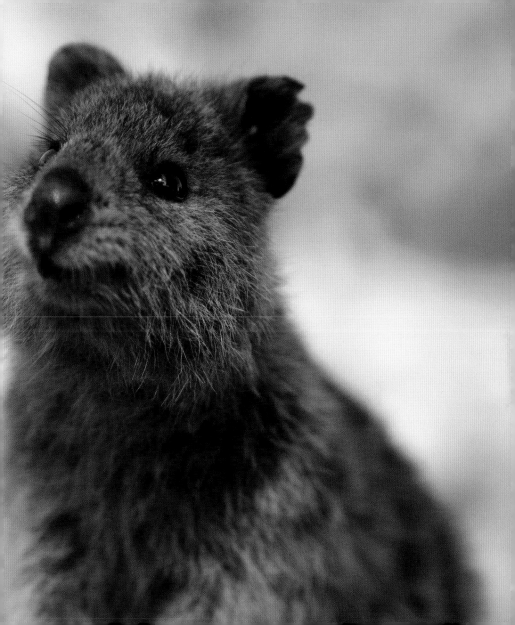

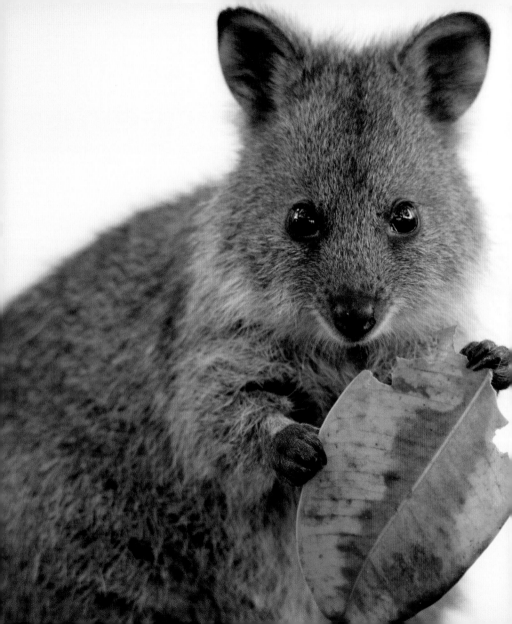

'I am not afraid of storms,
for I am learning how
to sail my ship'

———

LOUISA MAY ALCOTT

'Life is like riding a bicycle.
To keep your balance
you must keep moving'

———————

ALBERT EINSTEIN

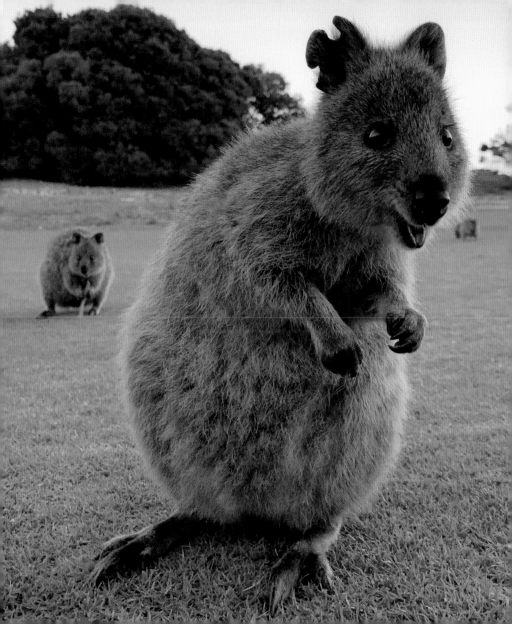

It's been my experience
that you can nearly
always enjoy things if
you make up your mind
firmly that you will

**LUCY MAUD
MONTGOMERY**

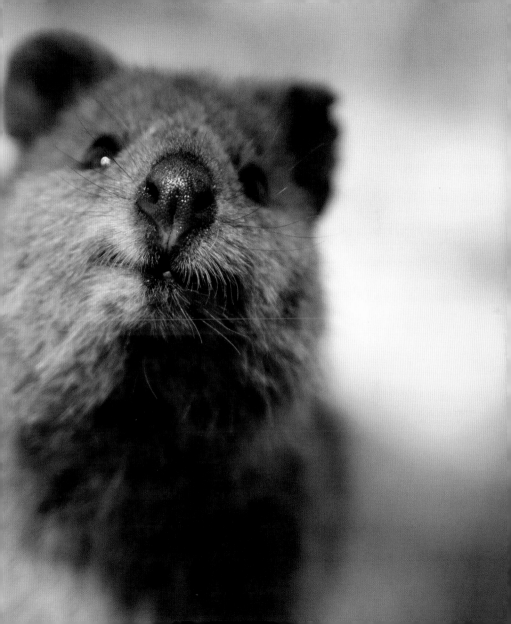

'The better part of one's life
consists of its friendships'

———————

ABRAHAM LINCOLN

'How truly is a kind heart
a fountain of gladness, making
everything in its vicinity
freshen into smiles'

———

WASHINGTON IRVING

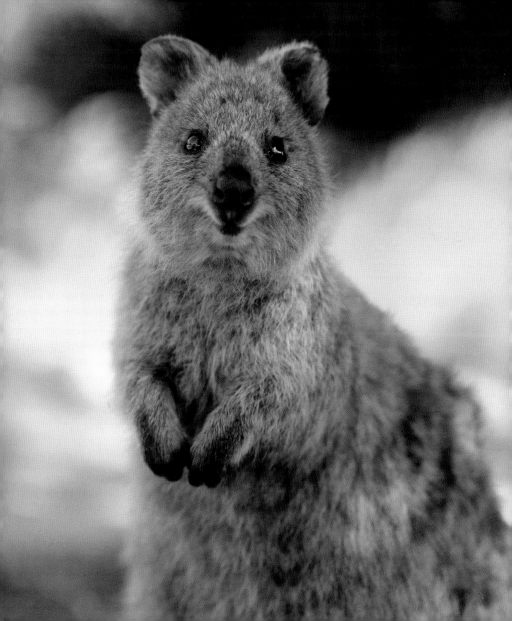

'The good life is one
inspired by love and
guided by knowledge'

———

BERTRAND RUSSELL

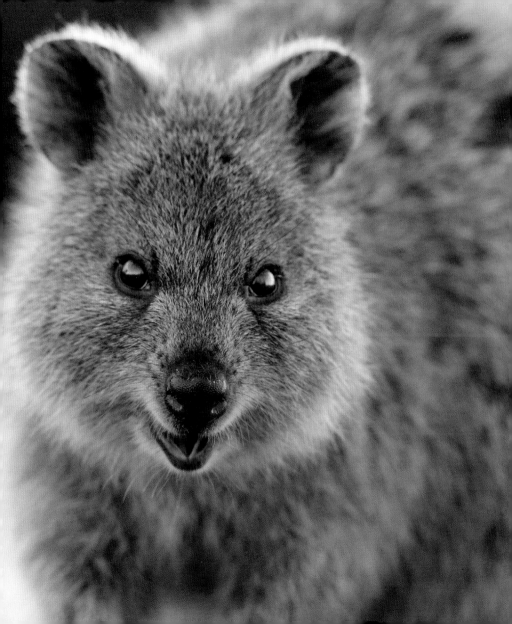

'The greater part of our happiness or misery depends upon our dispositions, and not upon our circumstances'

MARTHA WASHINGTON

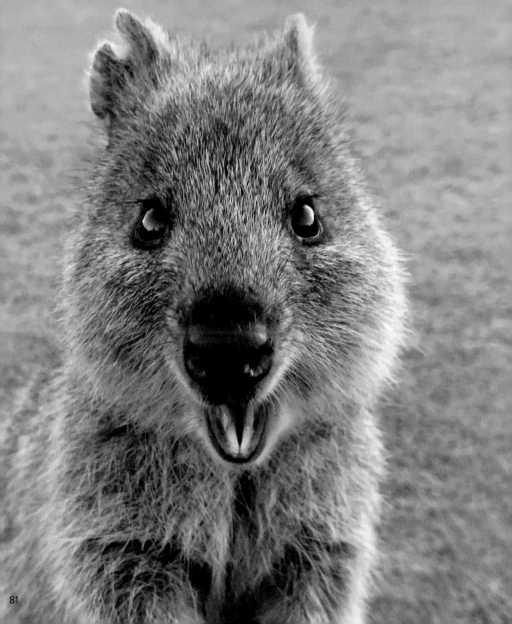

'Happiness is not in the mere possession of money; it lies in the joy of achievement, in the thrill of creative effort'

FRANKLIN D. ROOSEVELT

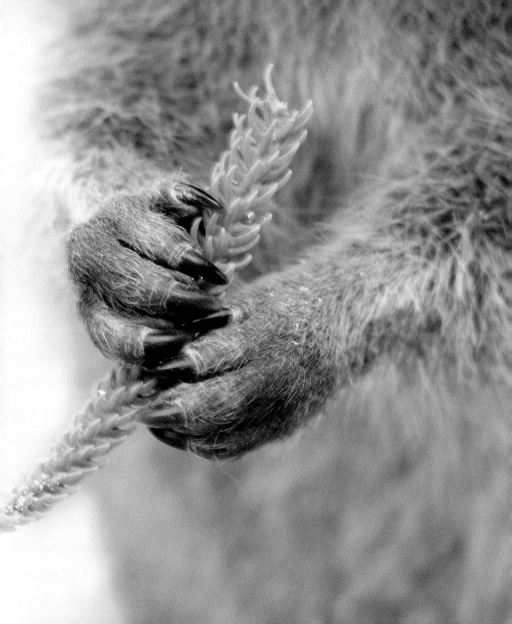

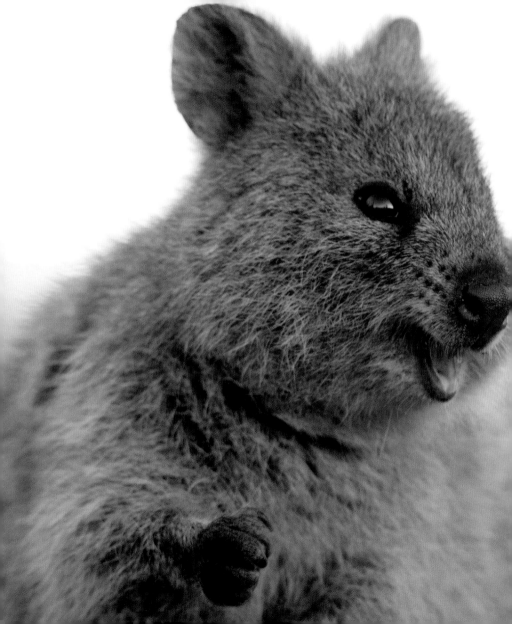

'Genius is one percent
inspiration, and ninety-nine
percent perspiration'

———

THOMAS EDISON

'Our doubts are traitors
And make us lose the good
we oft might win
By fearing to attempt'

WILLIAM SHAKESPEARE

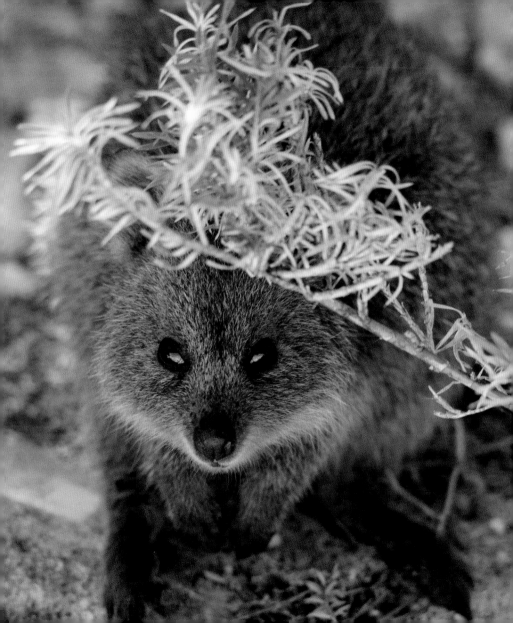

'Bliss is not an ideal of reason,
but of the powers
of imagination'

———————

IMMANUEL KANT

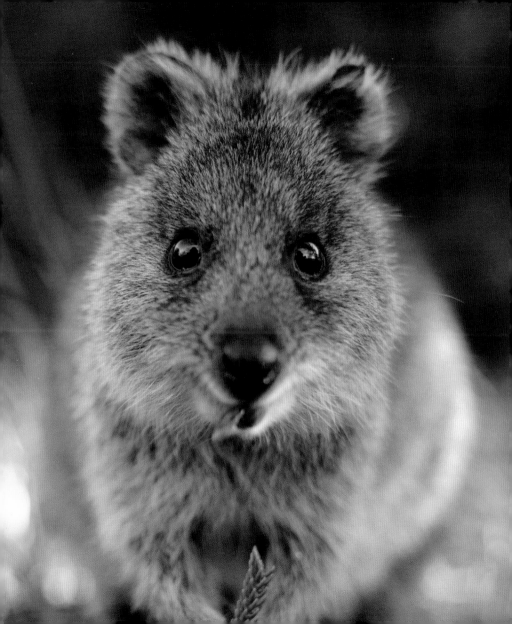

'They must often change
who would be constant
in happiness or wisdom'

**ANALECTS
OF CONFUCIUS**

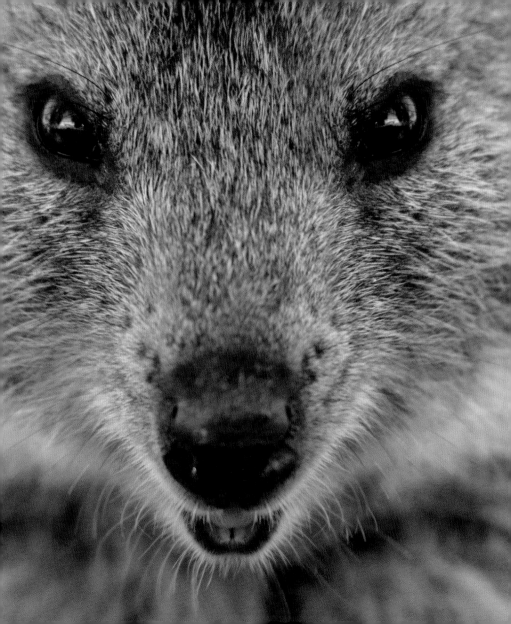

'Beware; for I am fearless,
and therefore powerful'

———————

MARY SHELLEY

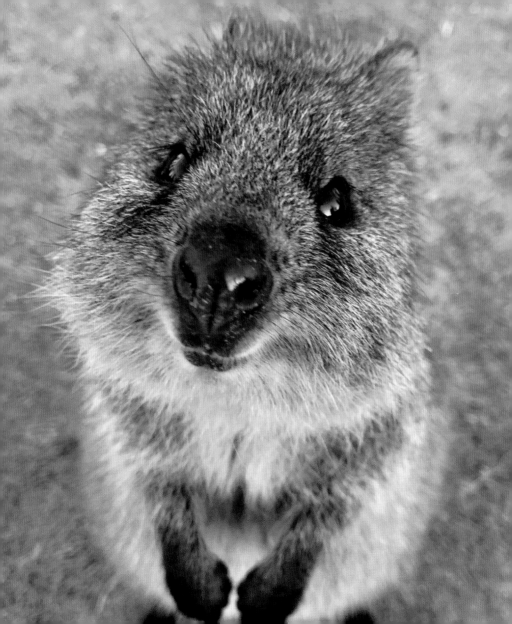

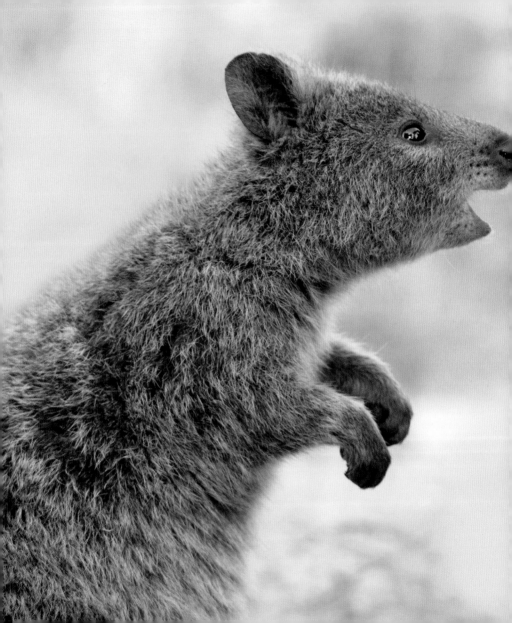

'He who sings
scares away his woes'

———

MIGUEL
DE CERVANTES

'Happiness is in ... the quiet of ordinary things. A table, a chair, a book with a paper-knife stuck between the pages. And the petal falling from the rose, and the light flickering as we sit silent'

VIRGINIA WOOLF

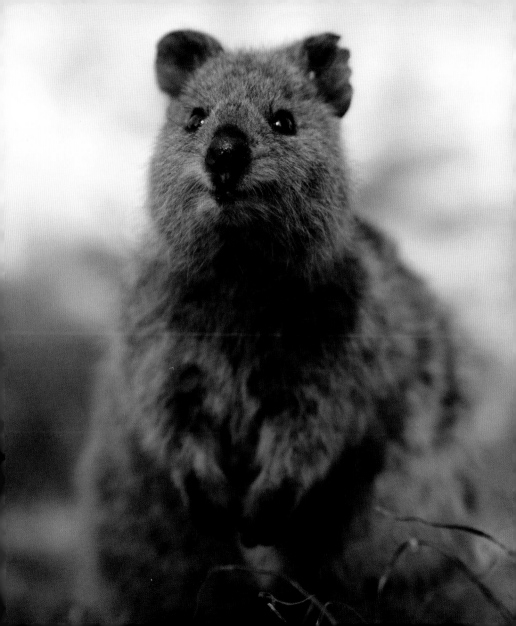

‘To thine own self
be true’

———

WILLIAM SHAKESPEARE

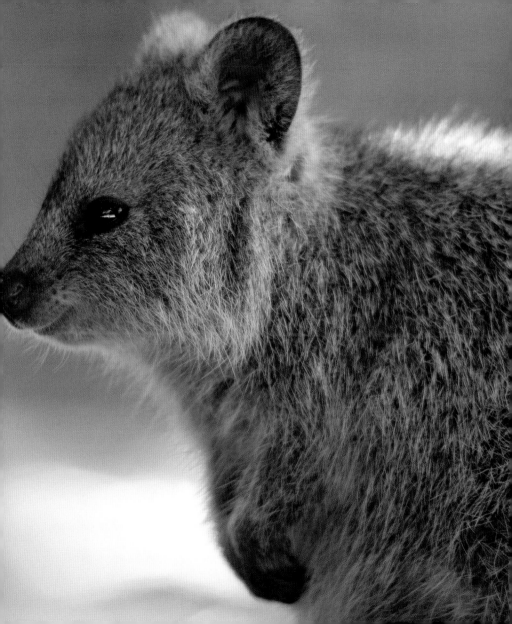

'A journey of a thousand miles begins with a single step'

———

LAOZI

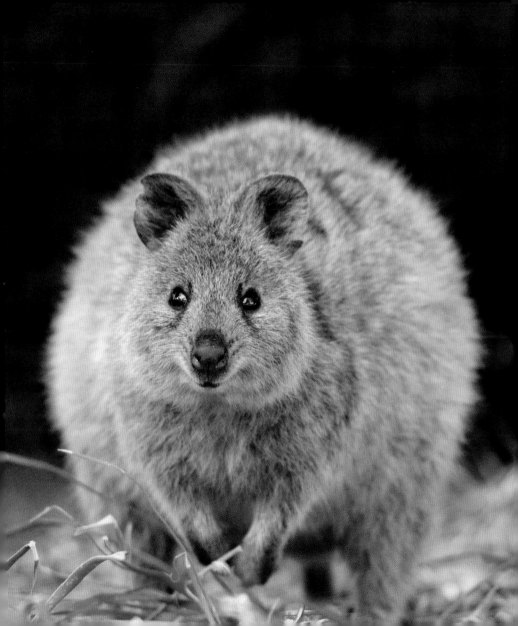

'I shall be of some use to the world ... it is the only way to be happy'

———

HANS CHRISTIAN ANDERSEN

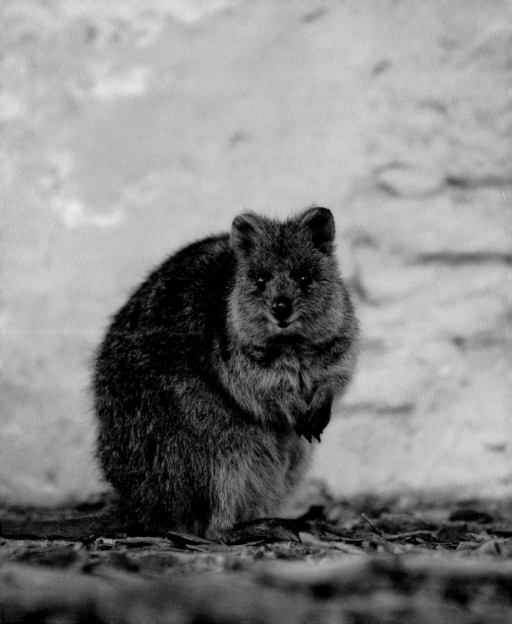

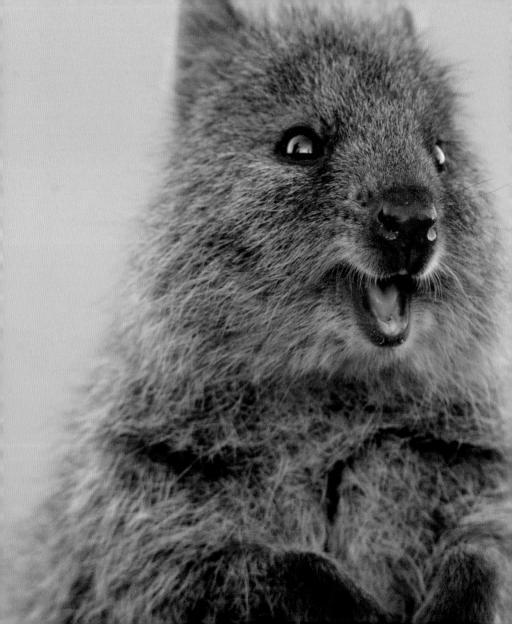

'Nothing great was ever
achieved without enthusiasm'

SAMUEL TAYLOR COLERIDGE

'If everyone were cast in the same mould, there would be no such thing as beauty'

CHARLES DARWIN

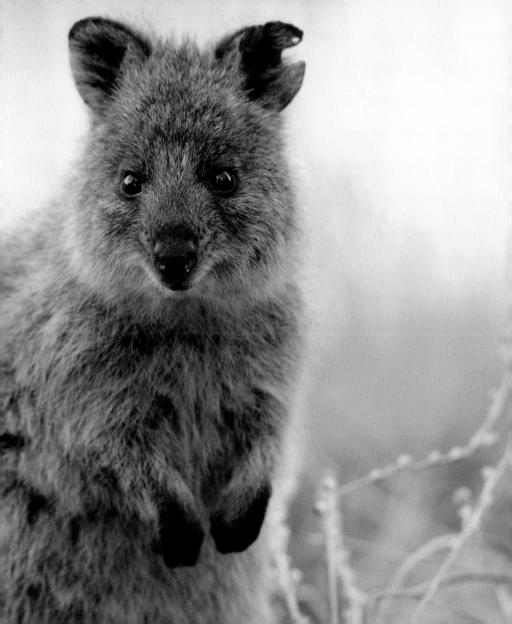

'What you do, or dream
you can, begin it.
Boldness has genius, power
and magic in it. Begin it now'

———

JOHANN WOLFGANG
VON GOETHE

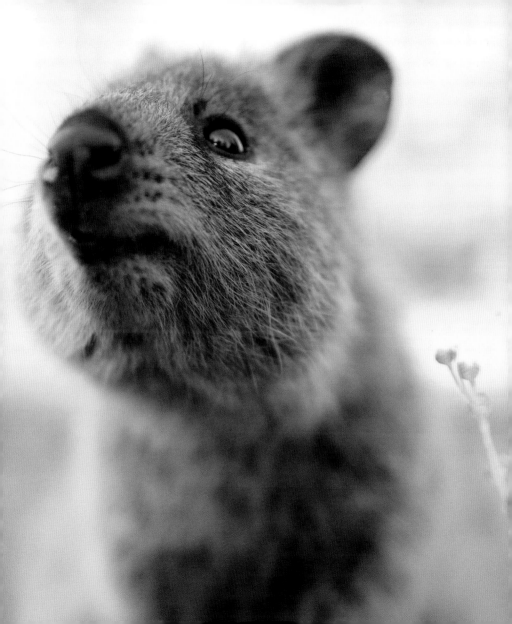

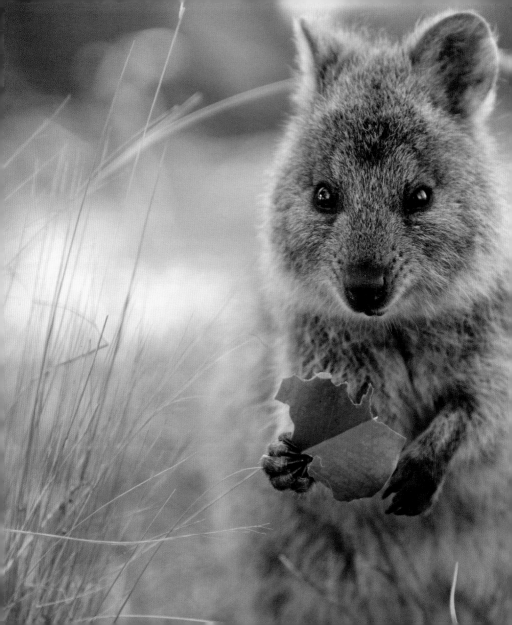

'Those only are happy
(I thought) who have their minds
fixed on some object other
than their own happiness;
on the happiness of others, on
the improvement of mankind'

JOHN STUART MILL

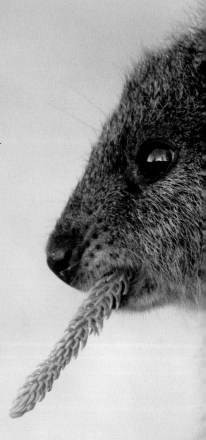

'The true secret of happiness lies in taking a genuine interest in all the details of daily life'

———————

WILLIAM MORRIS

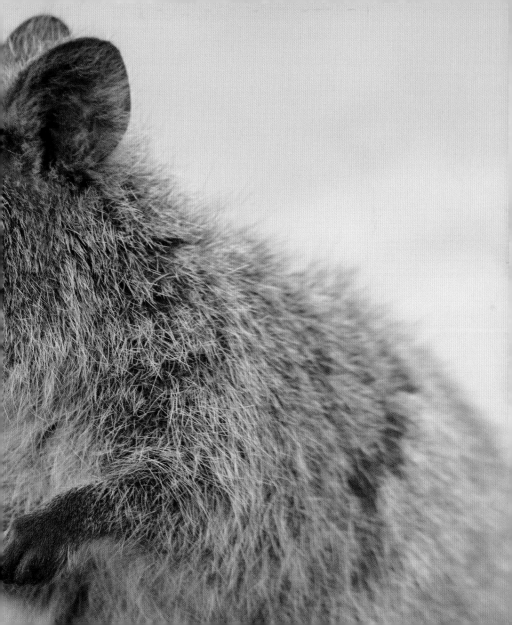

'All who joy would win
must share it – happiness
was born a twin'

———

LORD BYRON

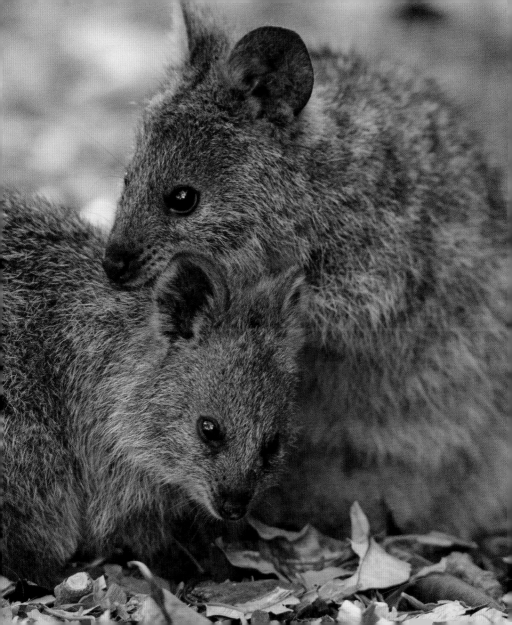

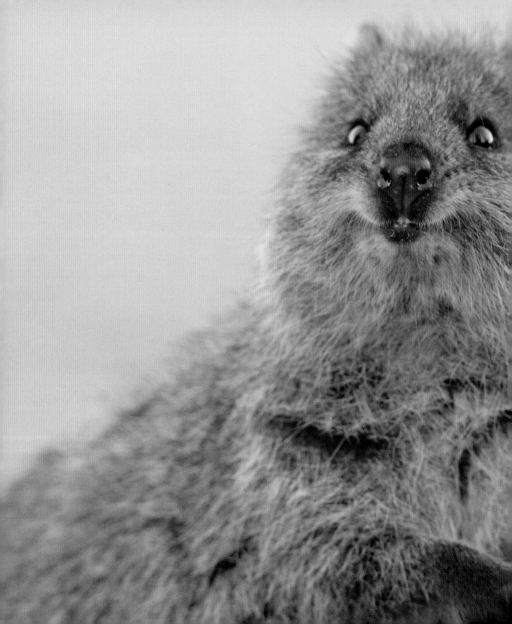

'All human wisdom
is contained in
these two words –
wait and hope'

ALEXANDRE DUMAS

'A gentle word, a kind look,
a good-natured smile
can work wonders and
accomplish miracles'

J.F. WRIGHT
AND L. SWORMSTEDT

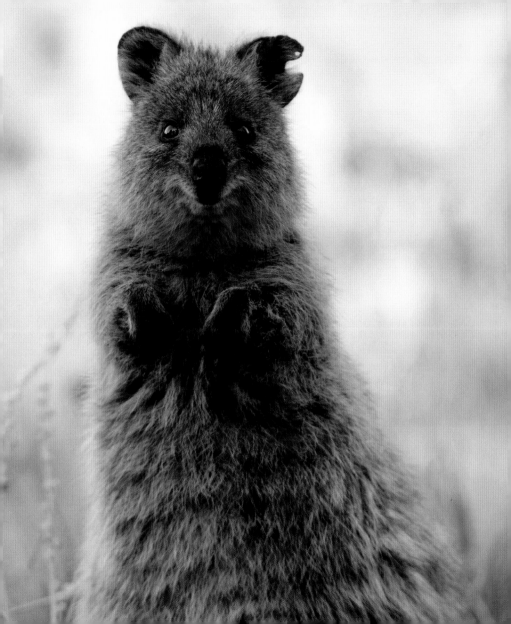

'The secret of reaping the greatest fruitfulness and the greatest enjoyment from life is to live dangerously'

FRIEDRICH NIETZSCHE

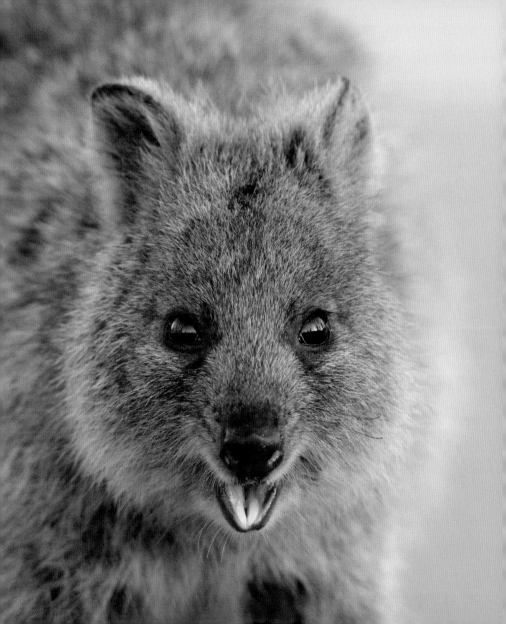

The happiness of life ...

is made up of minute

fractions – the little,

soon-forgotten charities

of a kiss, a smile,

a kind look, a heartfelt

compliment

———

**SAMUEL TAYLOR
COLERIDGE**

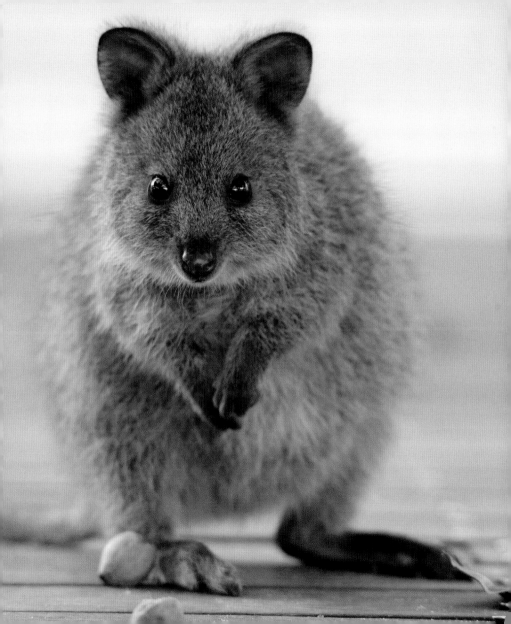

'One of the deep secrets of life
is that all that is really worth the
doing is what we do for others'

––––––––––

LEWIS CARROLL

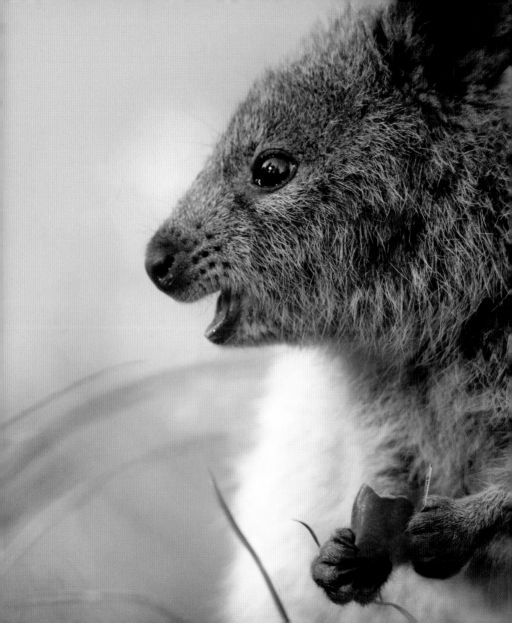

'I would always rather
be happy than dignified'

———

CHARLOTTE BRONTË

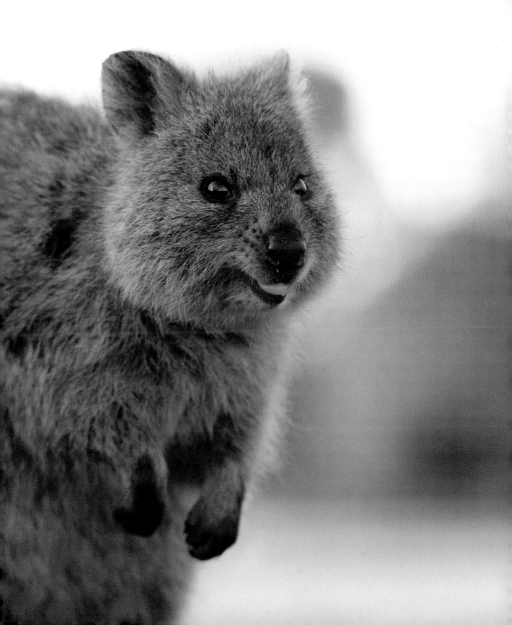

how to photograph a quokka

Quokkas are naturally inquisitive, super friendly and unafraid of humans. It's easy to understand why so many celebrities and visitors to their home on Rottnest Island want to snap a selfie.

How to photograph a quokka safely:

1. Be respectful and careful – safety of the quokkas comes first.

2. Remember, quokkas are wild animals and you are visiting their home.

3. Quokkas in the Settlement (townsite) area are more likely to be friendly.

4. Get your camera ready.

5. Sit quietly nearby and wait for them to come to you – do not approach them.

6. Never touch or pat a quokka, as this could make you both sick.

7. If they are camera shy, don't tempt them with food or water.

8. If taking a selfie, use a selfie stick to maintain respectful distance.

9. No one loves a camera in their face all day – once you've got your shot, be sure to sit back and spend some non-screen time with the quokkas.

Source: https://www.rottnestisland.com/protectwildlife

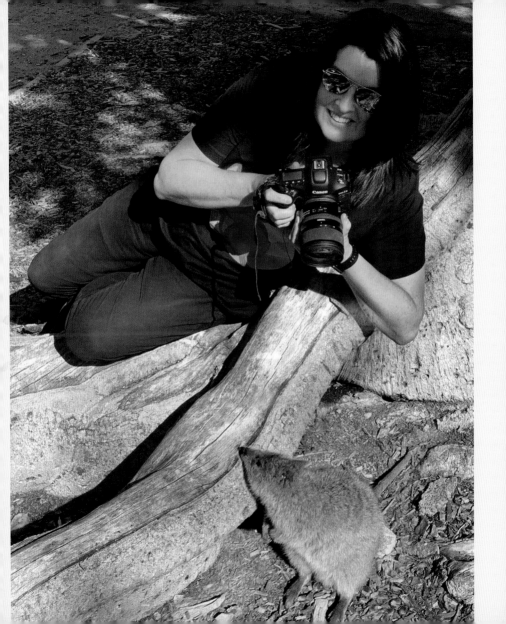

Rottnest Island

some facts about Rottnest Island

Rottnest Island has a rich history, spanning multiple cultures and generations. The traditional owners of Rottnest Island are the Whadjuk Nyungar people. They call the island Wadjemup, which means 'place across the water where the spirits are'. Aboriginal artefacts on the island date back from 6500 to more than 30,000 years ago.

In 1696, Dutch explorers mistook quokkas for giant rats and named the island Rottnest, which literally translates to 'rats' nest'.

During the 1800s, Rottnest Island served as a grim prison for Aboriginal inmates and later a boys' reformatory. In the 1900s, it was used for military operations, army barracks and briefly an internment camp for prisoners of war during World War I and World War II. It was reinvented as a holiday island from the early 1900s (aside from the brief periods of exclusive wartime military use).

Today, the island is colloquially known as 'Rotto', and around 700,000 day trippers or holiday makers visit the island each year.

Covering an area of just 19 square kilometres (a little over 7 square miles), the island is blessed with 63 spectacular white sandy beaches and turquoise bays, impressive marine life and a casual atmosphere.

Rottnest can be reached easily by ferry from Fremantle, Perth or Hillarys Boat Harbour. The island is car-free and bicycles are a popular mode of transport. They can be hired on the island or brought from the mainland. There is also a daily hop-on/hop-off bus service, which transports visitors to many of the secret hideaways and secluded bays located around the island.

A range of accommodation is available on the island throughout the year.

For more information on everything about Rottnest visit:
https://www.rottnestisland.com/

the Rottnest Island Authority

Rottnest Island is classified as an A-Class Reserve, the highest level of protection afforded to public land. It is managed by the Rottnest Island Authority (RIA), which operates under the provisions of the *Rottnest Island Authority Act 1987*. The RIA is a statutory body reporting to the Minister for Tourism in Western Australia. All plants and animals on Rottnest Island are protected by law.

The Act gives the RIA the power to control and manage Rottnest Island for the following purposes: to provide and operate recreational and holiday facilities on Rottnest Island; to protect the flora and fauna of Rottnest Island; and to maintain and protect the natural environment and the man-made resources of Rottnest Island to the extent that the RIA's resources allow, and repair its natural environment.

Source: http://ria.wa.gov.au/

sources

'AnAge entry for *Setonix brachyurus*', AnAge: the animal ageing and longevity database, 2014 (http://genomics.senescence.info/species/entry.php?species=Setonix_brachyurus)

Atlas of Living Australia: *Setonix brachyurus* (Quoy & Gaimard, 1830) (https://bie.ala.org.au/species/urn:lsid:biodiversity.org.au:afd.taxon:6e0e413a-e59c-413b-9d16-3d20b1bab707)

Fauna Profile, *Setonix brachyurus* (https://www.dpaw.wa.gov.au/images/documents/plants-animals/animals/animal_profiles/quokka_fauna_profile.pdf)

Macropodidae (https://en.wikipedia.org/wiki/Macropodidae)

'Meet the Quokka, the Happiest Animal in the World' (photos) (https://www.huffingtonpost.com.au/2013/01/07/quokka-happiest-animal-in-world_n_2426133.html?ri18n=true)

'Quokka', A–Z Animals, 2016 (http://a-z-animals.com/animals/quokka/)

Quokka (*Setonix brachyurus*) Recovery Plan, Western Australian Wildlife Management Program No.56, January 2013 (https://www.environment.gov.au/system/files/resources/4581df81-0041-4fc9-ba1b-aca7cb22246d/files/quokka-recovery-plan.pdf)

Quokka, *Setonix brachyurus* (https://australianmuseum.net.au/learn/animals/mammals/quokka/)

Quokkas: The Happiest Animals on the Internet (https://animalogic.ca/animalogic/quokkas-the-happiest-animals-on-the-internet)

Rottnest Island (https://www.rottnestisland.com/the-island/about-the-island/quokkas-and-wildlife)

Rottnest Island (https://en.wikipedia.org/wiki/Rottnest_Island#Tourism_and_facilities)

Rottnest Island Authority (http://ria.wa.gov.au/)

'*Setonix brachyurus* – Quokka Glossary', *Species Profile and Threats Database*, Department of the Environment, Canberra

Species Profile and Threats Database: *Setonix brachyurus* – Quokka (https://www.environment.gov.au/cgi-bin/sprat/public/publicspecies.pl?taxon_id=229)

biographical notes

Aesop (6th century BC), 'The Lion and the Mouse', *Aesop's Fables*. Ancient Greek storyteller.

Louisa May Alcott (1832–88), *Little Women*, 1868. American writer and author.

Hans Christian Andersen (1805–75), *The Flax*, 1848. Prolific Danish writer of plays, novels, travelogues and poems, but best remembered for his fairy tales.

Aristotle (384–322 BC), *The Nicomachean Ethics*, c. 340 BC. Ancient Greek scientist and philosopher. One of the greatest and most influential figures in the history of Western thought.

Charlotte Brontë (1816–55), letter to W.S. Williams, 19 March 1850; and *Jane Eyre*, 1847. The eldest of three English sisters, all of whose novels are classics.

Buddha (c.563–c.483 BC), *The Aranna Sutta of the Samyutta Nikaya*. Born in Nepal; ancient spiritual teacher and philosopher, founder of Buddhism.

Lord Byron (1788–1824), *Bride of Abydos*, 1814; and *Don Juan*, 1819–24. English Romantic poet, best known for his narrative poems.

Lewis Carroll – pen name of Charles Lutwidge Dodgson (1832–98), letter to Ellen Terry, 13 November 1890. English writer and mathematician; author of *Alice's Adventures in Wonderland*.

Miguel de Cervantes (1547–1616), *Don Quixote*, 1605. Spanish author whose novel has inspired operas, ballets, films and musicals.

Samuel Taylor Coleridge (1772–1834), *The Statesman's Manual*, 1816; and 'The Improvisatore', 1828. English poet and a founder of the Romantic movement.

Confucius (551–479 BC), *Analects*. Ancient Chinese philosopher, teacher and political theorist.

Charles Darwin (1809–82), *The Descent of Man*, 1871. English naturalist, biologist and founder of the evolutionary theory of natural selection.

Benjamin Disraeli (1804–81), *Lothair*, 1870. Twice-serving Conservative British prime minister, and a novelist.

Alexandre Dumas (1802–70), *The Count of Monte Cristo*, 1845. French playwright and author of adventure novels, including *The Three Musketeers*.

Thomas Edison (1847–1931), *Harper's Magazine*, 1932. American physicist and prolific inventor of electrical devices, including the gramophone, talking motion pictures and the incandescent light bulb.

Albert Einstein (1879–1955), *Ideas and Opinions*, 1954; and letter to his son Eduard, 5 February 1930. German-Swiss-American theoretical physicist who developed the theory of relativity and the world's most famous equation, $E=mc^2$.

Henry Rutherford Elliot (1849–1906), *A Recipe for Sanity*, 1906. American author and *New York Times* journalist.

Ralph Waldo Emerson (1803–82), *Essays, Second Series*, 1844. American essayist, poet and leader of the transcendentalist movement.

André Gide (1869–1951), *The Counterfeiters*, 1925. French novelist, essayist and dramatist. Recipient of the 1947 Nobel Prize for Literature.

Johann Wolfgang von Goethe (1749–1832), *Faust*, 1808. German poet, novelist, playwright, diplomat and natural philosopher.

Oliver Goldsmith (1728–74), *The Citizen of the World*, 1760–61. Irish poet, novelist, essayist, playwright and busker. Works include *The Vicar of Wakefield* and *She Stoops to Conquer*.

Maxim Gorky (1868–1936), *The Lower Depths and Other Plays*, 1901. Russian socialist and author.

Victor Hugo (1802–85), *Les Misérables*, 1862. French poet and author; leader of the French Romantic Movement; also wrote *The Hunchback of Notre-Dame*.

Washington Irving (1783–1859), *TThe Sketch Book of Geoffrey Crayon, Gent*, 1819. American diplomat, short-story writer, and biographer.

Immanuel Kant (1724–1804), *Groundwork to the Metaphysic of Morals*, 1785. German philosopher of epistemology, ethics and aesthetics.

John Keats (1795–1821), *Endymion*, 1818. English Romantic poet. His other works include 'Ode on a Grecian Urn' and 'The Eve of St Agnes'.

Laozi (6th century BC), *Tao Te Ching* (*The Way of Power*). Ancient Chinese philosopher and founder of Taoism.

Abraham Lincoln (1809–65), letter to Joseph Gillespie, 13 July 1849. America's sixteenth president; fought to preserve the Union in the American Civil War and abolished slavery.

Herman Melville (1819–91), *Moby-Dick*, 1851. American novelist; other works include *Billy Budd*.

John Stuart Mill (1806–73), *Autobiography*, 1873. English philosopher and social reformer, proponent of Utilitarian ethical theory and an early feminist.

Lucy Maud Montgomery (1874–1942), *Anne of Green Gables*, 1908. Canadian author of twenty novels.

William Morris (1834–96), *The Aims of Art*, 1886. English socialist, poet and master-craftsman; he created patterns for fabric and wallpaper, as well as typefaces and stained-glass.

Friedrich Nietzsche (1844–1900), *The Joyous Science*, 1882. German scholar, cultural critic and philosopher, concerned with the underlying morality that motivates Western religion.

James Oppenheim (1882–1932), *War and Laughter*, 1916. American poet, novelist and founder of literary magazine *The Seven Arts*.

Thomas H. Palmer (1782–1861), *The Teacher's Manual*, 1840. American printer, author and education reformer.

Alexander Pope (1688–1744), *Mr D'Urfey's Last Play*, 1713–17. English poet and satirist.

Marcel Proust (1871–1922), *Pleasures and Days*, 1896. French novelist who wrote *In Search of Lost Time*.

Franklin D. Roosevelt (1882–1945), Inaugural Address, 4 March 1933. American president who led his nation throughout the Great Depression and World War II.

Bertrand Russell (1872–1970), *What I Believe*, 1925. Welsh philosopher, mathematician and author of many controversial books on social, moral and religious topics.

Antoine de Saint-Exupéry (1900–44), *The Little Prince*, 1943; and *Wind, Sand and Stars*, 1939. French writer and pilot.

George Sand – pen name of Amandine Dupin (1804–76), letter to Lina Calamatta, 31 March 1862. French novelist, biographer, playwright and socialist.

William Shakespeare (1564–1616), *Measure for Measure*, 1623; and *Hamlet, Prince of Denmark*, 1603. World-renowned English poet and playwright.

Mary Shelley (1797–1851), *Frankenstein*, 1818. English writer; famous for this moving gothic novel written in her late teens.

Bessie Anderson Stanley (1879–1952), 'What is Success?', 1904. American writing competition entrant; her prize-winning poem about success is often misattributed to Robert Louis Stevenson.

Robert Louis Stevenson (1850–94), *An Apology for Idlers*, 1877. Scottish novelist, most noted for *Treasure Island* and *Strange Case of Dr Jekyll and Mr Hyde*.

Virgil (70–19 BC), *Aenid*, X, 19 BC. Ancient Roman poet, best known for this epic telling of Rome's foundation.

Martha Washington (1732–1802), letter to Mercy Otis Warren, 26 December 1789. Wife of George Washington, first president of the USA.

Virginia Woolf (1882–1941), *The Waves*, 1931. English novelist, essayist and feminist; pioneer of the stream of consciousness narrative style. Other works include *Mrs Dalloway* and *To the Lighthouse*.

J.F. Wright and L. Swormstedt, *The Ladies' Repository*, vol.14, 1854. Founders of a Methodist publishing house based in Ohio.

acknowledgements

Every book is a huge team effort and nothing comes to fruition without the collaboration of many trusted sources. The HarperCollins Australia team are exceptional, and I love being a part of their publishing family.

First and foremost, my sincere thanks go to Helen Littleton, Head of Australian Non-Fiction. I really appreciate your understanding of animal book content and our mutual excitement we had for this book. Your support for my photography is also appreciated and it's an honour to work with you again.

To the fabulous HarperCollins team who helped guide this book: managing editor Belinda Yuille for her editing; Mark Campbell, head of the HarperCollins Design Department, for his direction; publishing co-ordinator Eleanor Macavei for sourcing the quotes; and graphic designer Shirley Tran Thai for her wonderful design. You have all been integral in this process and made it so easy. Thank you!

To the Rottnest Island Authority, who granted me permission to photograph quokkas on Rottnest Island, and particularly to Narelle Brough, the Marketing and Events Officer – biggest thanks! Without your generous time, support and endorsement this book wouldn't exist. Narelle, you went above and beyond to help me with inside info on the island and the behaviour patterns of the quokkas, and that information was vital when it came to capturing the images I needed.

Lastly, thanks to Deb, who was by my side for every image taken – in work and in life.

Alex Cearns

about Alex Cearns OAM

Dogs Today magazine in the United Kingdom called Alex Cearns 'one of the greatest dog photographers in the world.'

Australian photographer Alex Cearns crafts exquisite animal portraits that convey the intrinsic joy people find in animals. As Creative Director of Perth-based Houndstooth Studio, she photographs around 1300 animals per year. Her clients include engaged pet lovers, leading corporate brands and around 40 Australian and international animal charities and conservation organisations. Her images have been published extensively in worldwide media, books, magazines and ad campaigns.

An undisputed leader in her niche, Alex is the recipient of more than 350 awards for her photography, business and philanthropy. She is a Master Photographer with the Australian Institute of Professional Photography, a Pro Team Ambassador for Tamron's Super Performance Series Lenses in Australia and the United States, and Brand Ambassador for Profoto, BenQ and Spider Camera Holster.

Deeply committed to the wellbeing of all creatures great and small, Alex is considered one of Australia's most passionate champions and voices for animal rescue and wildlife conservation. Her advocacy and philanthropy were distinguished with a Medal of the Order of Australia (OAM) from the Council for the Order of Australia for her service to the community through charitable organisations.

She lives with her partner, two rescue dogs and rescue cat in Perth, Western Australia.

Website http://www.houndstoothstudio.com.au

Facebook https://www.facebook.com/HoundstoothStudio

other books by Alex Cearns

Mother Knows Best: Life Lessons from the Animal World (Penguin, 2014)

Joy: A Celebration of the Animal Kingdom (Penguin, 2014)

Things Your Dog Wants You to Know (Penguin, 2015), with Laura Vissaritis, dog behaviourist

Zen Dogs (HarperCollins, 2016)

Perfect Imperfection: Dog Portraits of Resilience and Love (ABC Books, 2018)

For the Love of Greyhounds (ABC Books, 2018)

The ABC 'Wave' device is a trademark of the
Australian Broadcasting Corporation and is used
under licence by HarperCollins*Publishers* Australia.

HarperCollins*Publishers*
Australia • Brazil • Canada • France • Germany • Holland • Hungary
• India • Italy • Japan • Mexico • New Zealand • Poland • Spain
• Sweden • Switzerland • United Kingdom • United States of America

First published in Australia in 2020
by HarperCollins*Publishers* Australia Pty Limited
Level 13, 201 Elizabeth Street, Sydney NSW 2000
ABN 36 009 913 517
harpercollins.com.au

A catalogue record for this book is available from the National Library of Australia

ISBN 978 0 7333 4109 0

Cover and internal photography by Alex Cearns
Cover and internal design by Shirley Tran Thai
Typesetting and layout by Jude Rowe, Agave Creative Group
Author photo by Debora Brown
Colour reproduction by Graphic Print Group, Adelaide
Printed and bound in China by RR Donnelley on 128gsm matt art

6 5 4 3 2 21 22 23